LIBRARIES AROUND THE WORLD
COLORING BOOK

by Lacey Losh

COLORING
with Lacey

Creatively celebrating the joy of reading - in every corner of the world!

ISBN 978-0-9969907-0-7

This publication was created and designed by Lacey Reque DiPaolo Losh of Coloring with Lacey.

For more information about Coloring with Lacey, free downloads of coloring sheets
and previews of upcoming projects, visit: coloringwithlacey.com

This coloring book is dedicated to my parents, Bob & Donna DiPaolo.

They have been with me every step of the way, providing encouragement and support, not only for this project but in all aspects of my life. They are my biggest fans and my greatest critics, offering invaluable insight and guidance. They knew I could do this and so I have! The image at left is a small-scale line drawing of their library, Wings of the Air.

A special thanks goes to my partner Andira for her love and support as this project took over our lives. Together we work to create a better, more inclusive community. As stewards, our library is open to all people in hopes that it can become a neighborhood hub, allowing for the free exchange of ideas and knowledge, as well as an inviting shared resource which belongs to us all. Creativity and free culture are important to both Andira and I. This coloring book, focusing on libraries, embodies two of our shared passions in a unique way.

Thanks to my Aunt Linda and Uncle Jeff Fleming for building and delivering the Losh Free Library that graces our front yard. (You can read more about this project on the next page.) Thank you for your time and enthusiasm!

Thanks to the sponsorship level crowd funding campaign backers
who have helped make this project a reality:

Blair & Deanna Denny
Bob & Donna DiPaolo
Michael Mucci
Heidi & Lonnie Pavel
Clarisse Robertson

Losh Free Library
Location: Lincoln, Nebraska, United States

Lacey and Andira Losh are the stewards of the Losh Free Library. Lacey heard a report about little libraries on National Public Radio in 2012 and hoped to someday host a free book exchange in front of her home. However, as busy community organizers, Lacey and Andira set aside the little library dream with hopes of someday making it a reality.

Little did they know, shortly after expressing their interest, Lacey's parents commissioned her uncle to build them a little library! On July 23, 2013 Lacey's family surprised her and Andira with a lovely wooden library made of leftover materials from her uncle's deck project.

Andira and Lacey's lives have been enriched in ways they couldn't have imagined since becoming library stewards. They've cultivated relationships with other stewards in their community and around the world. Lincoln has a thriving network of little library stewards who have come together to spread awareness of free book exchanges and to help promote literacy initiatives. With the help of local business, nonprofits and community-minded individuals, little library locations in Lincoln have skyrocketed in the past two years. There are currently 60 libraries in the Lincoln area, but the count has been known to change rapidly!

Happiness 101
Location: Xindian District, New Taipei City, Taiwan

Houston Wen is the steward of the first little library to be built in Taiwan, Republic of China. It's located at the Mei Zhi Cheng Community Park.

The library is named "Happiness 101" which means you can enjoy happiness in the library more than 100%!

Houston is grateful to his daughter, Jia Rong, for building the library and happy that it allows him to share his lifelong interest in reading with others.

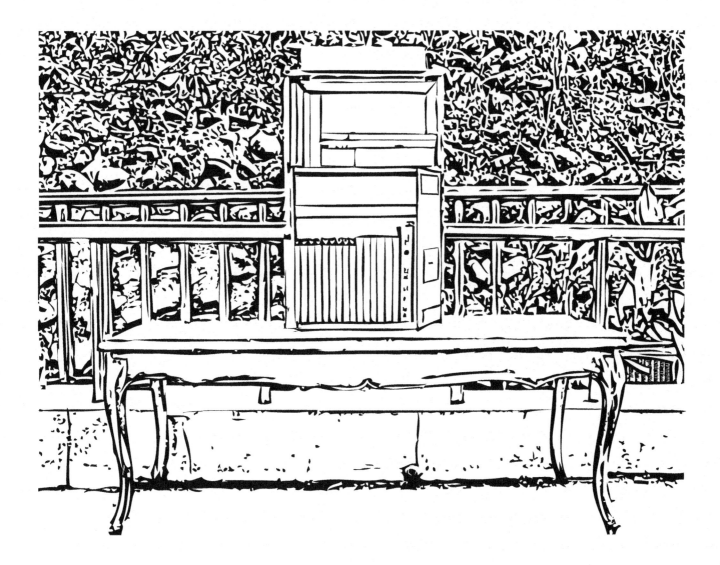

Location: **Bismarck, North Dakota, United States**

Lori Riehl's house and library sit on a street that ends at a gas station. The gas station has an ice cream counter and on summer evenings, families walk past the library on the way to buy ice cream cones. On any given day you can grab a sweet treat and a book on the same outing!

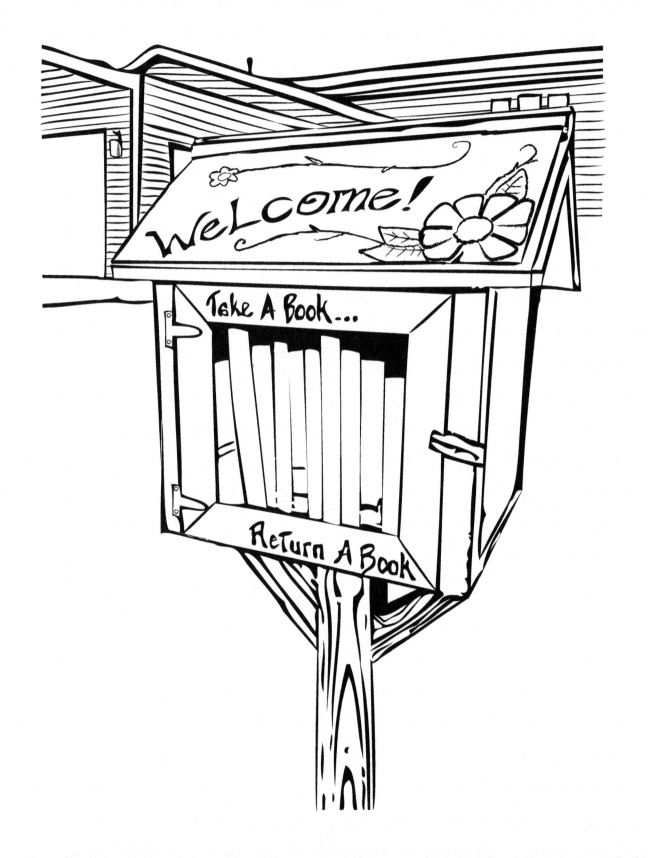

6th Street Library
Location: Fenton, Michigan, United States

The 6th Street Library offers more than free books to neighbors and visitors. Divided plants from the garden, such as hostas and purple cone flowers, have been shared. This little library also doubles as a geocache site where treasure hunters and adventurers can find extra trinkets! Have a four-legged friend? Bring them by this little library to snag a treat from the dog bone box that's attached to the side!

Follow this library on Facebook and on Instagram: @6thstreetlibrary

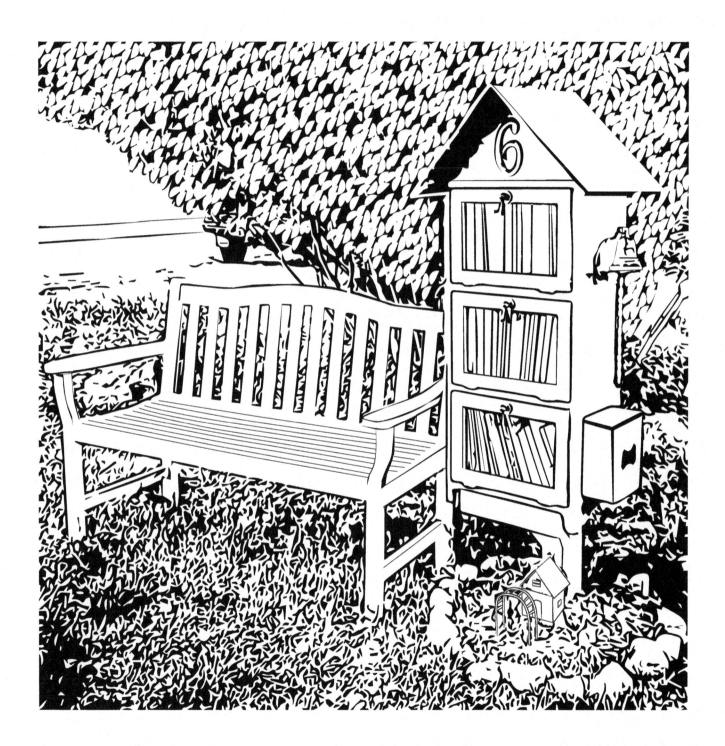

Camrose Book Bike
Location: Alberta, Canada

The Camrose Book Bike is the first one in Alberta and was started in the summer of 2015. The bike itself was ordered from New York and the box was built by one of their awesome patrons. A past summer student thought up the Book Bike logo and painted the box with a beehive that looks like a stack of books accompanied by bees, as well as flowers with gears in the center.

The Camrose Book Bike rides to playgrounds, parks and seniors homes, making books available to those who can't necessarily come to a library. The Book Bike does everything a library can do, including programming, checking in and out library materials and opening new memberships.

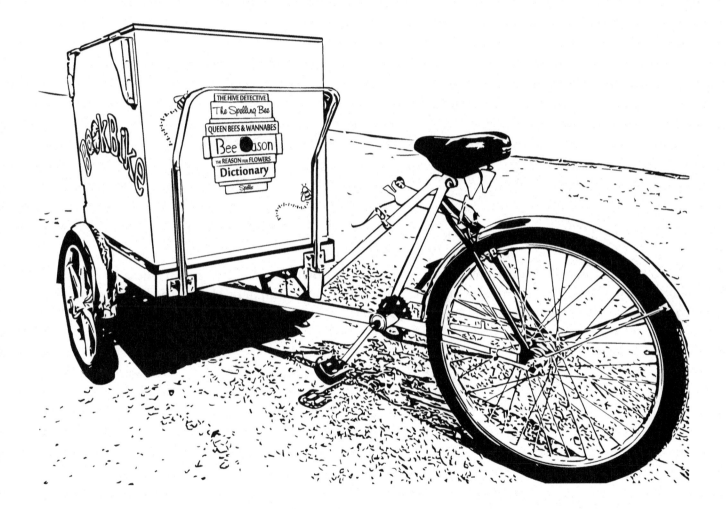

Location: **Minnesota, United States**

This book box is in a small town in east central Minnesota. The steward has nine siblings, and more than 75 nieces and nephews. Many of her family members generously donate wonderful books for re-circulation. The library is on a fairly busy residential street with the foot traffic of mostly younger people, some with adult accompaniment. A notebook inside lets visitors leave comments; some are ideas for selections and many are notes of appreciation. The steward loves to read - immersion in books takes her to places, times and situations far removed from her own experience. Perhaps most importantly, the steward's days are sometimes complicated by depression and anxiety. Having the library allows her to give and receive from the community in a pleasant way for herself and the neighborhood.

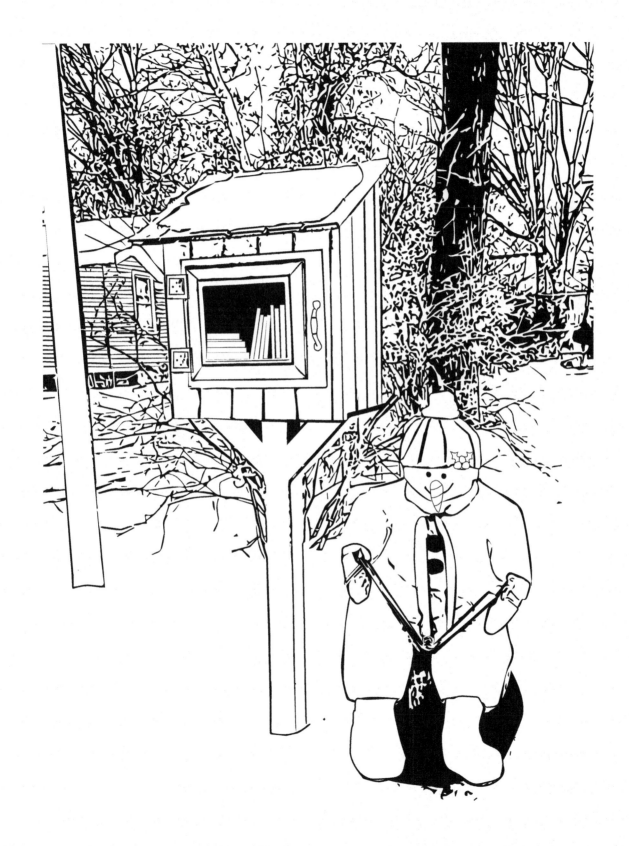

The Bicycling Bunny

Location: Chino, California, United States

The Bicycling Bunny's neighborhood was established as a Literacy Friendly Neighborhood in May of 2015, and was recognized as a Library of Distinction in January of 2015. The Bicycling Bunny has an extensive online presence, check out their blog for more information and photos of the library:

http://thebicyclingbunny.tumblr.com/

Meet the bunnies!

Pay a visit and see these friendly faces gracing The Bicycling Bunny library:

Gatsby - The dapper library mascot that's always well dressed in his vest and ascot, pedaling un-ironically on his bicycle. (Gatsby is pictured atop the library on the coloring sheet!)

Wilde & Twain - Twin wise cracking bunnies who guard the library post. Wilde is stylishly flamboyant, while Twain is the inquisitive sort.

Daisy, Jordan & Myrtle - The sassy girl bunny trio that have the Roaring Twenties at heart. They are fun, flirty and flappers to all that jazz.

Carraway - He's not only a voracious reader, but is also an accomplished carrot connoisseur.

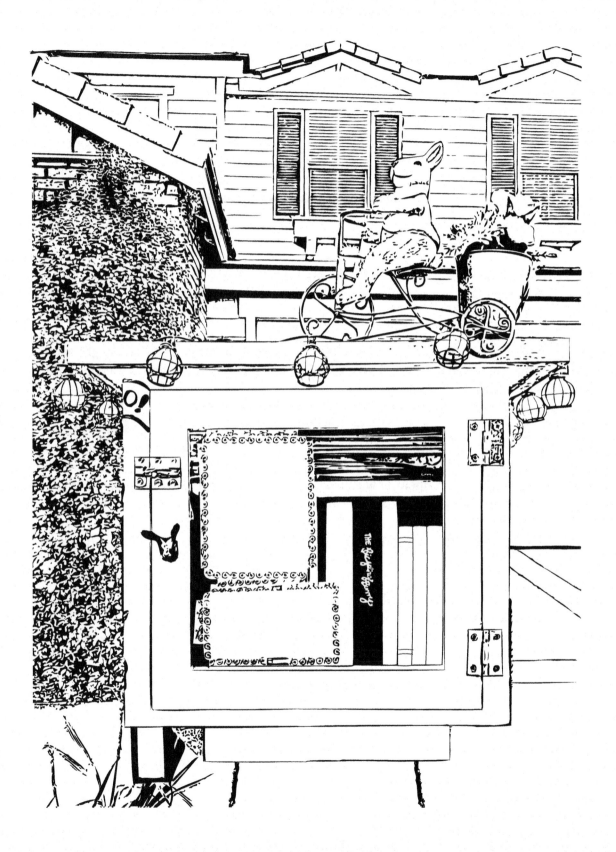

Location: **Drongen, Belgium**

Nathalie Leclercq opened her little library in February 2015.

She works in a library at the University of Ghent and books are her life, her way to escape the banalities and hassle of daily life. She loves philosophy, the biographies of writers from the 19th century, and books that dig into one's head.

When she moved into her current home, she knew immediately that this was the right spot - not only to start decorating the house but also to plant a little library in the front yard. It's a dead-end street but with lots of social interaction.

Before her library was launched, she wrapped it in beautiful red paper with a huge ribbon around it. The wrapping was displayed for two weeks, to make people curious. During that time Nathalie visited all 65 houses on her street telling neighbors about her library and how it works. She invited them all as well as her friends to the grand opening with free cake and apple juice. People reacted enthusiastically. Though it was chilly outside, she was surrounded by smiling faces.

Nathalie now has weekly visitors. Many small children live on her street and she often notices short legs dangling from the bench near her library, which melts her heart.

In her spare time, Nathalie enjoys reading to three children from a family who came from Niger. The parents do not speak Dutch, her language, but the children love to be read to in Dutch, helping them learn the language. Nathalie finds it gratifying to help children with reading by taking them to the library.

Bennett Martin Public Library
Location: Lincoln, Nebraska, United States

While there are many local libraries that hold a special place in Lacey Losh's heart, the Bennett Martin Public Library in Lincoln Nebraska always has an edge. A courtyard graces the center of this downtown library that includes pools of water, sculpture art and an array of plants and trees. Even in the winter months, this courtyard is a thing of beauty under a blanket of newly fallen snow.

Lacey's parents brought her to their neighborhood public library weekly, but it was a special treat to travel downtown and browse the expansive children's book selection at Bennett Martin, ride the glass elevator and all the while, enjoy the view of the courtyard.

This coloring page serves as a tribute to those fond childhood memories, especially with the likelihood that Lincoln will build an updated, larger downtown library in the near future. Naturally, Lacey hopes that blueprints for the new library design will include a courtyard.

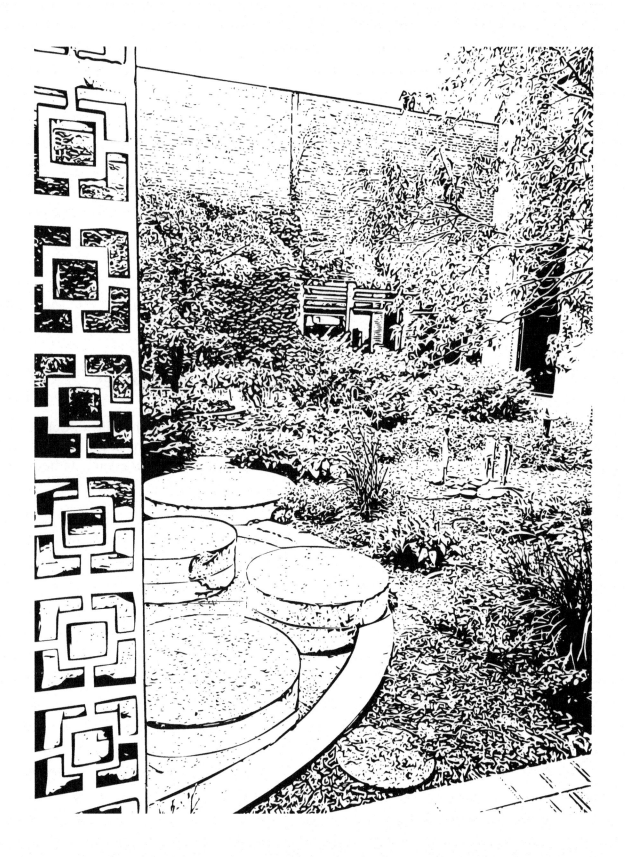

Location: **Bloomfield, Connecticut, United States**

This little library is next to a Montessori School on one of the main roads in Bloomfield, Connecticut, which guarantees a lot of foot traffic. Visitors, especially children, love to check on the library and restock it every Wednesday. They also leave other surprises inside the library, such as homemade bookmarks.

Location: **New Orleans, Louisiana, United States**

Elizabeth Maltby's New Orleans library is a memorial for her father.

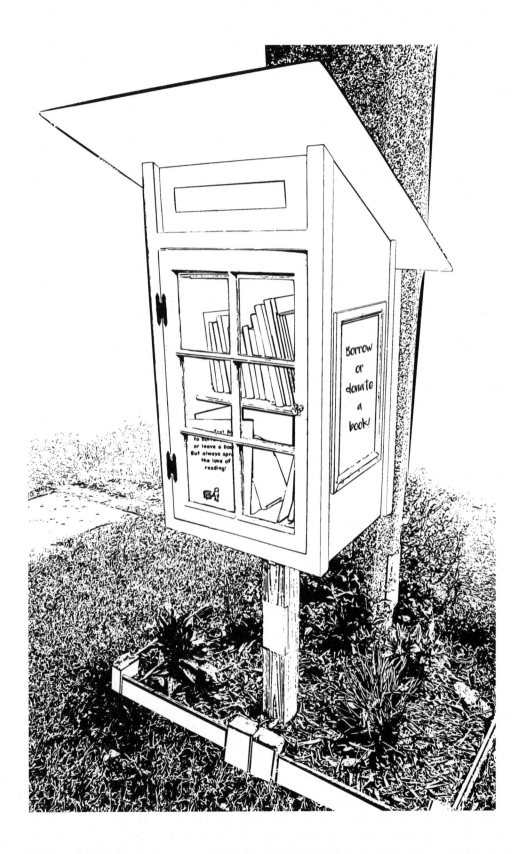

Location: **Clearfield, Pennsylvania, United States**

"There are worse crimes than burning books.
One of them is not reading them."

–Joseph Brodsky

This quote expresses how Joyce Graham feels about reading. It's also a reoccurring thought she has when she notices people walking by her little library without a second glance, especially parents with children.

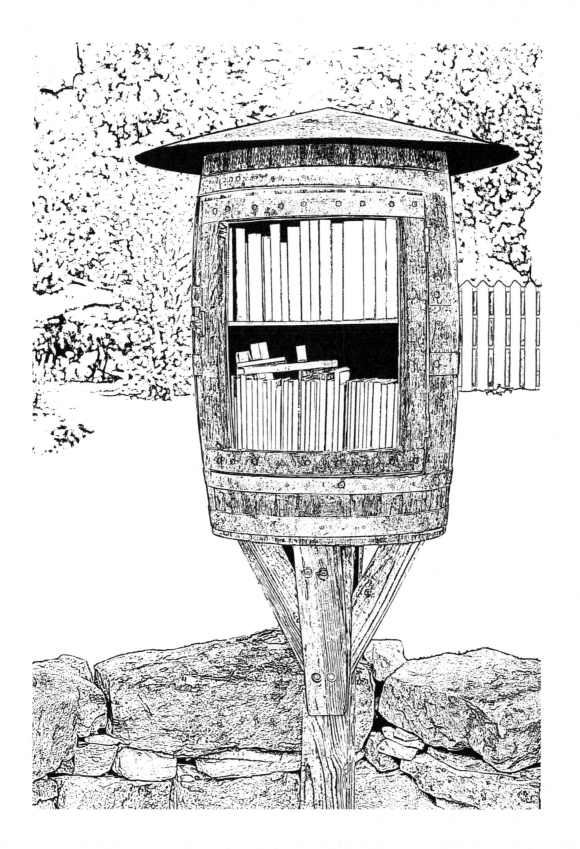

Location: **Crystal, Minnesota, United States**

Two of Tanya Smutka's passions are running her little library, which was built by her husband, and coloring. So, it was a natural fit for her library to be a part of this coloring book collection focusing on libraries around the world! Her library had it's grand opening in the fall of 2014.

Location: **Saint Augustine, Florida, United States**

Tawny Kern is the steward of a library in Saint Augustine Florida, which is the nation's oldest city. This library was established at the Fullerwood Community Garden. Something special about Fullerwood is that it's a giving garden where they give away flower bouquets from the garden beds in recycled bottles. The library is also a recipe and seed exchange.

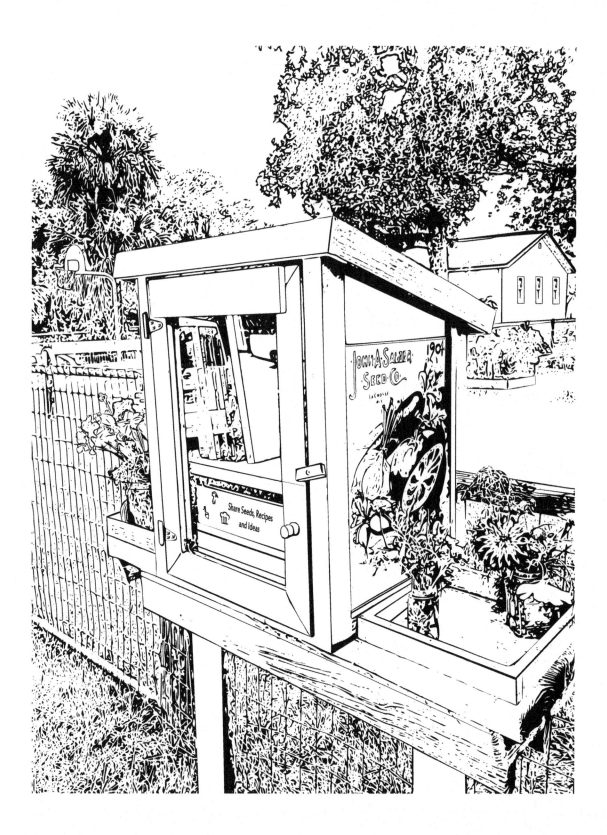

Location: **Ghana, West Africa**

Val Newman is the steward of this library in Ghana, West Africa. She is also the steward of the first little library in the Baltimore Urban Area. Val is doing great work encouraging a love of reading and promoting literacy across the globe.

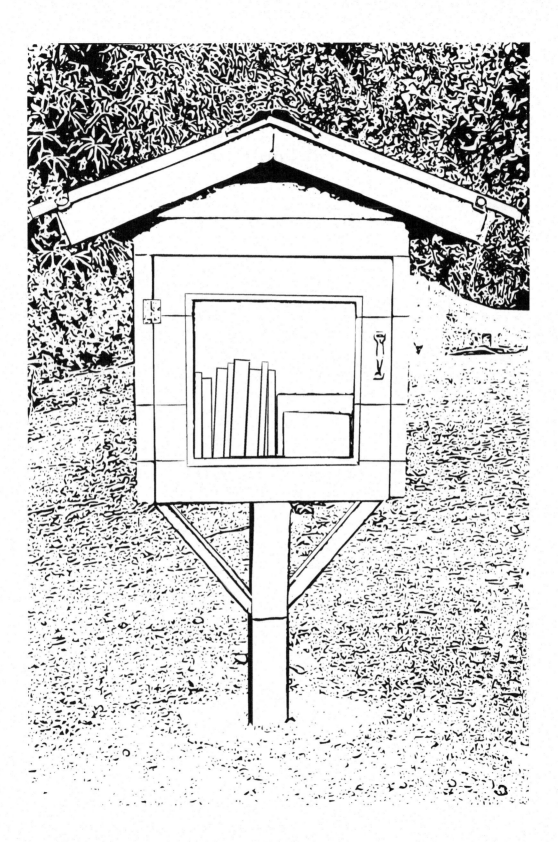

Evan's Port No. 1
Location: Spring Valley, Wisconsin, United States

Evan's little library in Spring Valley, WI, first opened April 18, 2015. This story begins a year before when Evan, along with his brothers, mom and grandparents took a drive to see the little red schoolhouse library on a post at 110 North St., Hudson, WI - home of Todd Bol.

This was the first time Evan and his brothers peered into a little library to see what treasures it had in-store for them. Evan had already been talking with his grandparents about having his own little library. After visiting Todd's library, Evan knew he wanted to learn more about it and get involved.

Evan chose to do his school volunteer presentation Student Expo Project on the subject of little libraries. Evan's grandparents and mom set-up an interview time with Todd and his staff, and invited Evan to 'do a build.' Little did Evan and his family know the library he helped build would be given to him.

Evan chose a lighthouse theme because of his love for lighthouses and because his home is situated on a corner lot much like a lighthouse is on a point of land. The name 'Evan's Port No. 1' was chosen because it reflects the fact that Evan also has a 'port' to help him fight Histiocytosis-a rare disease he's had since age 3.

Since Evan's presentation and the library's installment, it has been well received by his community. Evan's story was published in the local newspaper and in a blog post online.

Evan has been working on plans for an additional lighthouse-style library in the future (Evan's Port No. 2)! Evan especially enjoys visiting other libraries, occasionally meeting their stewards and stopping in to have conversations with Todd and the crew.

Evan's goal is to share his love of reading, spread Histiocytosis awareness, help build a stronger community and encourage others to join in the library fun!

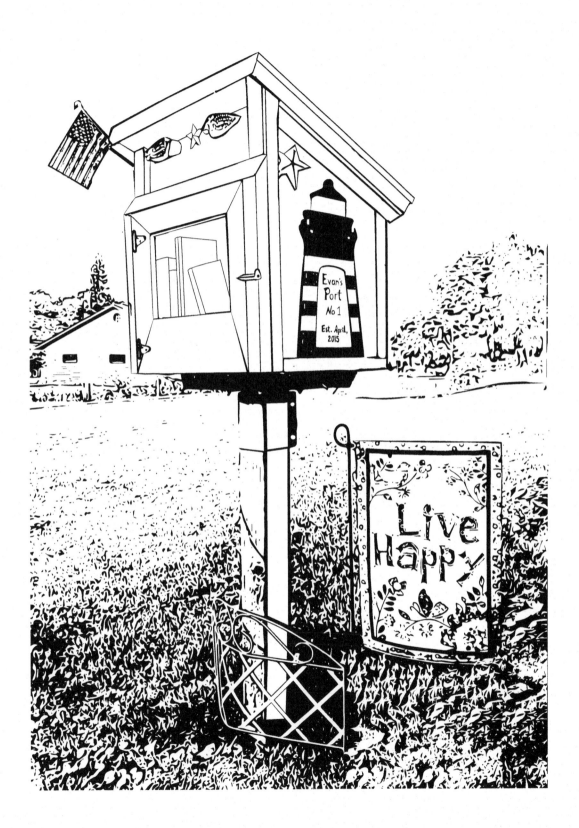

Keg Lane Book Exchange
Location: Paris, Ontario, Canada

When Clarisse Farnsworth and her husband started their Keg Lane Book Exchange it was to share their love of reading with neighbors, friends and people passing by - and also to share the wealth of their overflowing book shelves! Clarisse's husband built the not so little book shed and put it at the end of their driveway.

They quickly noticed that no one seemed interested and wondered why no one was coming by to see what it was all about. Eventually they realized that since they're living on a rural road, people thought it was a shelter for children waiting for their school bus! To correct this misconception, they placed a gigantic sign on their fence at the end of the driveway that reads "FREE BOOKS." Next, they delivered postcards telling people about the library. Thanks to their efforts, the library has caught on and has become popular with many visitors ever since.

Community Bookshelf

Location: Central Library, Kansas City, Missouri, United States

The Community Bookshelf is a striking feature of Kansas City's downtown. It runs along the south wall of the Central Library's parking garage on 10th Street between Wyandotte Street and Baltimore Avenue. The book spines, which measure approximately 25 feet by 9 feet, are made of signboard mylar. The shelf showcases 22 titles reflecting a wide variety of reading interests as suggested by Kansas City readers and then selected by The Kansas City Public Library Board of Trustees. Their final selection was made on March 16, 2004. The bookshelf was completed between March and the fall of 2004.

Full list of titles that appear on the Community Bookshelf:

- **Children's Stories** - One volume in the community bookshelf lists the following children's stories on its spine:
 - Goodnight Moon by Margaret Wise Brown
 - Harold and the Purple Crayon by Crockett Johnson
 - Winnie the Pooh by A. A. Milne
 - Green Eggs and Ham by Dr. Seuss
 - What a Wonderful World by George Weiss and Bob Thiele
 - Little House on the Prairie by Laura Ingalls Wilder
 - The Wonderful Wizard of Oz by L. Frank Baum
 - M.C. Higgins, the Great by Virginia Hamilton
- Catch-22 by Joseph Heller
- Silent Spring by Rachel Carson
- O Pioneers! by Willa Cather
- Cien Años de Soledad (One Hundred Years of Solitude) by Gabriel García Márquez
- Their Eyes Were Watching God by Zora Neale Hurston
- Fahrenheit 451 by Ray Bradbury
- The Republic by Plato
- Adventures of Huckleberry Finn by Mark Twain
- Tao Te Ching by Lao Tzu
- The Collected Poems of Langston Hughes by Langston Hughes
- Black Elk Speaks by Black Elk, as told to John Neihardt
- Invisible Man by Ralph Ellison
- To Kill a Mockingbird by Harper Lee
- Journals of the Expedition by Lewis and Clark
- Undaunted Courage: Meriwether Lewis, Thomas Jefferson, and the Opening of the American West by Stephen Ambrose
- The Lord of the Rings by J. R. R. Tolkien
- A Tale of Two Cities by Charles Dickens
- Charlotte's Web by E.B. White
- Romeo and Juliet by William Shakespeare
- Truman by David G. McCullough
- Kansas City Stories, Volumes 1 & 2

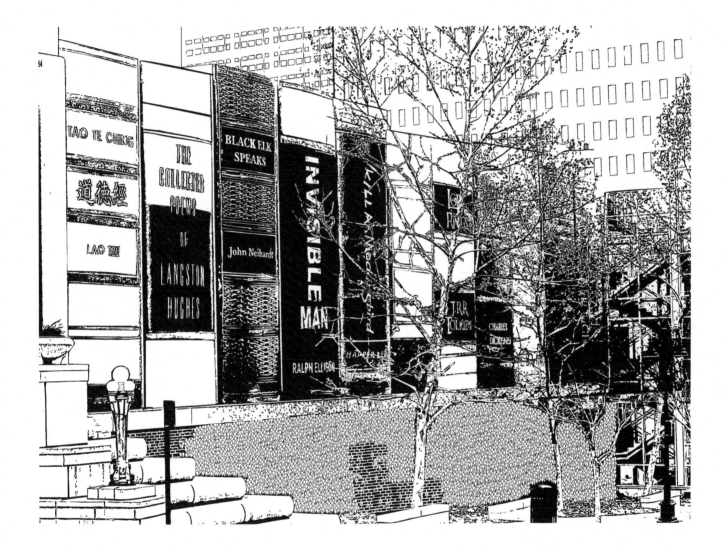

Location: **Rochester, New York, United States**

Linda Lawrence's library is located in the suburb of East Irondequoit, Rochester NY. The neighborhood really loves the library and it gets frequent visitors. The library has inspired others in Linda's area to become stewards as well. There are currently three libraries within a 3-mile radius!

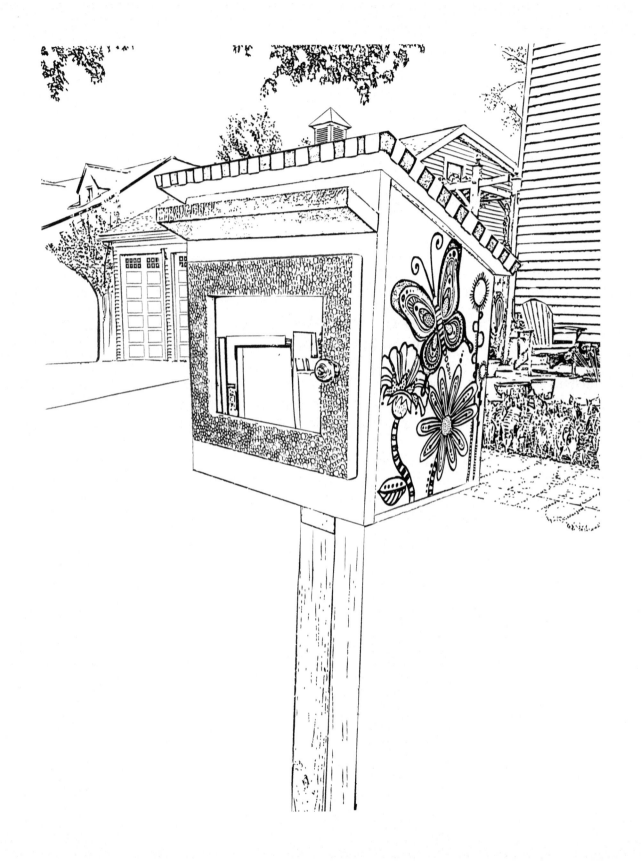

The Enchanted Owl
Location: Champlin, Minnesota, United States

Molly Schuster's little library was a Mother's Day gift from her husband just over a year ago. They have recently announced plans to have an artist and friend remodel the library this year. While Molly will be sad to see the button design go, she can't wait to see the work of art the library will become!

The Enchanted Owl was featured in the August 2015 issue of Family Fun Magazine! This truly has been an "enchanting" experience for Molly and her husband. She never imagined how many new friends she'd make by becoming a steward...not just in her local community, but around the world within the steward community! Also, check out The Enchanted Owl's Facebook page.

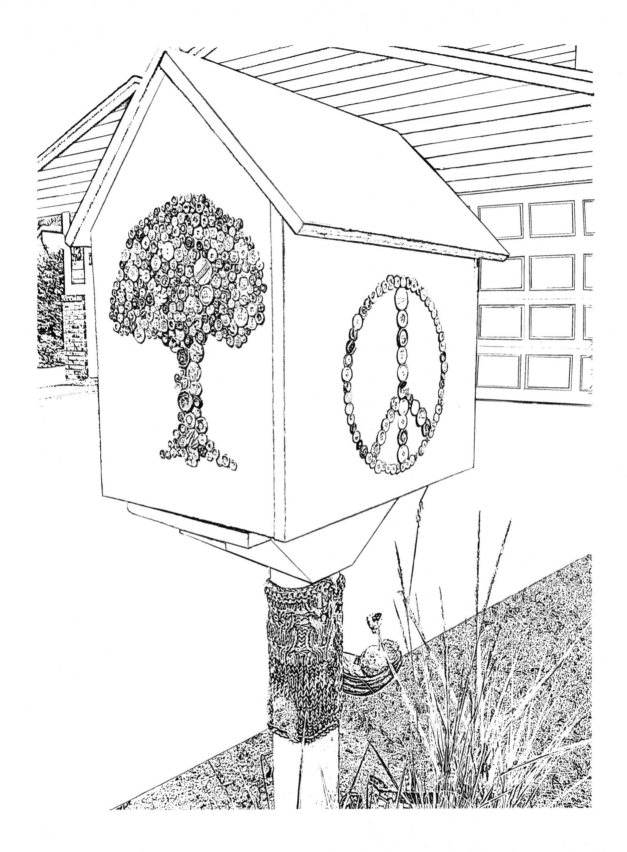

Location: **Calgary, Alberta, Canada**

This little library opened on May 4, 2015. It always has a mystery novel inside because the steward, Laurel Malialis, loves mysteries! There are sakura (cherry) blossoms and birds painted on the library for decoration.

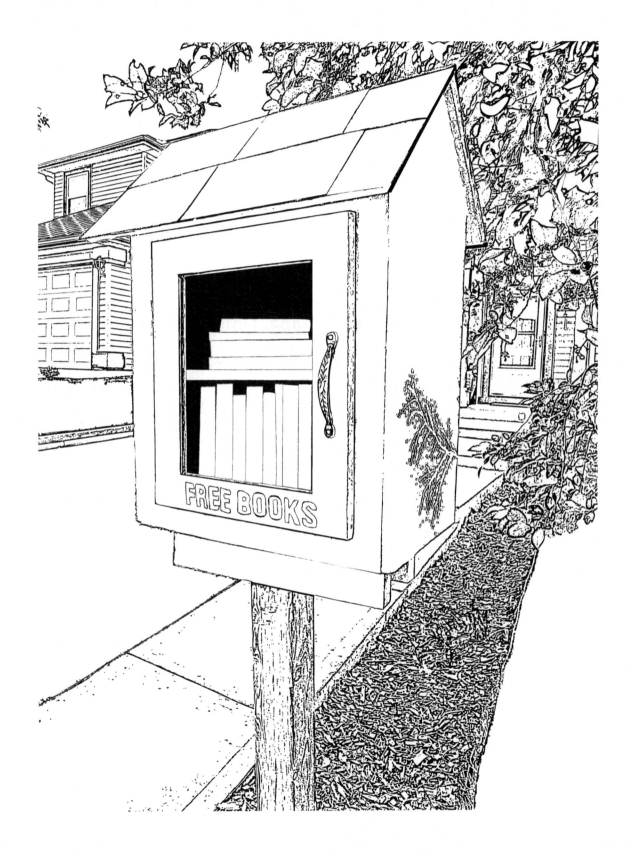

Location: **Monroe, Indiana, United States**

Holly Mishler, who submitted this library for consideration in the coloring book, is a great admirer and promoter of little libraries. She lives in the small town of Monroe, Indiana. Holly noticed that some rural areas and Amish populations are vastly under-served concerning libraries and reading materials. Holly has met with a city planner and a leader in the Amish community to discuss adding more little libraries in the area. Through her efforts, she hopes to see several new libraries being built in and around Monroe within the next year.

Holly enjoys visiting the library pictured here, located at Shaka Shack Coffee & More in Monroe. Public places like coffee shops make excellent locations for little libraries, especially in areas with fewer opportunities to obtain free reading material.

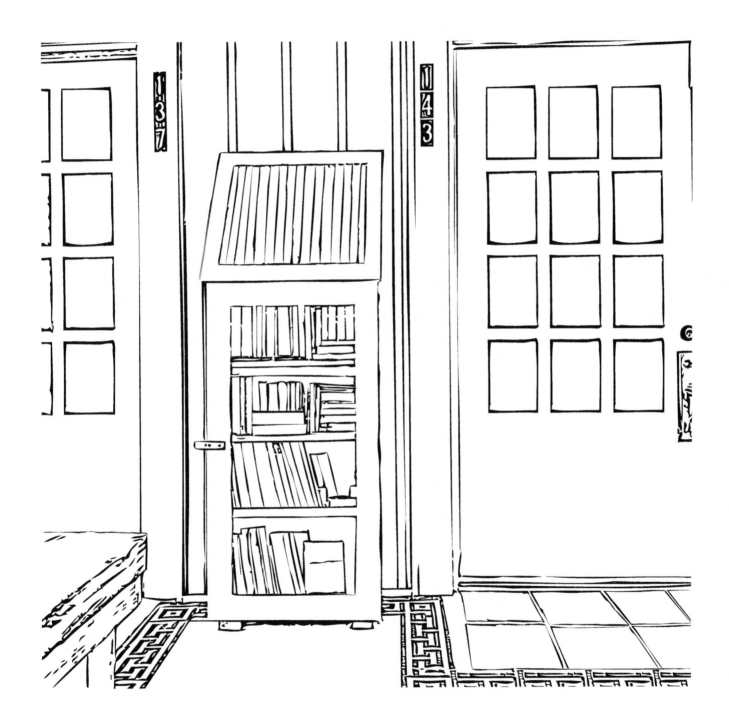

Location: **Morristown, New Jersey, United States**

Luanne McGovern's library was inspired by a trip to Wisconsin, where she saw many little libraries during her visit to the area. She lives in Morristown, NJ, which is a very "literary" town, and has a large library that hosts an annual Festival of Books.

Luanne is part of a very active book club and her neighborhood is full of avid readers. The design of this library is based on her house - a renovated 1895 carriage house. Luanne's husband did much of the wood work on their house and also designed and built their library. They live in the historic district of Morristown and the design fits well among the historical architecture.

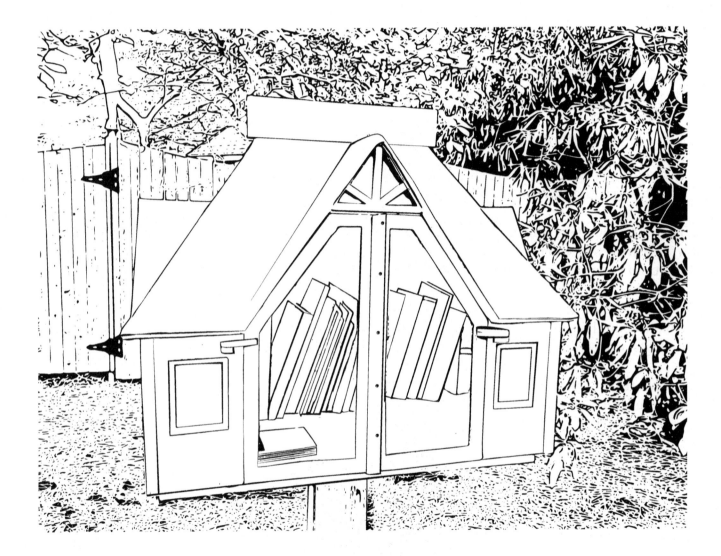

Montpelier, Vermont Library - In Memory of Jean Kay
Location: Montpelier, Vermont, United States

This library is located in Montpelier, Vermont. It's a memorial for Andrea Warnke's sister Jean Kay, who died in 2013. It was one of the libraries featured in Flow Magazine's article on little libraries (in their Dutch, English, and German issues).

This coloring page features the library in a classic Vermont winter scene and the accompanying story lends background on Andrea's choice of decoration:

Since 2002 the city of Montpelier (Vermont's state capitol) has found their downtown district plastered with hearts every Valentine's Day. Following suit, Andrea made a string of miniature versions of these hearts and hung them in her library on Valentine's Day.

Last year, sadly, the hearts didn't appear in downtown Montpelier. So, some local high school students took it upon themselves to put them up downtown anyway, to continue the tradition. Photos of the students' work were documented, and photos of Andrea's library were also included.

The heart that is featured so prominently in Montpelier is of a distinctive shape. The hearts hung in Montpelier have always been this particular one, copied many times over:

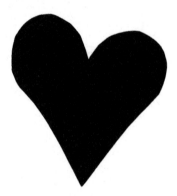

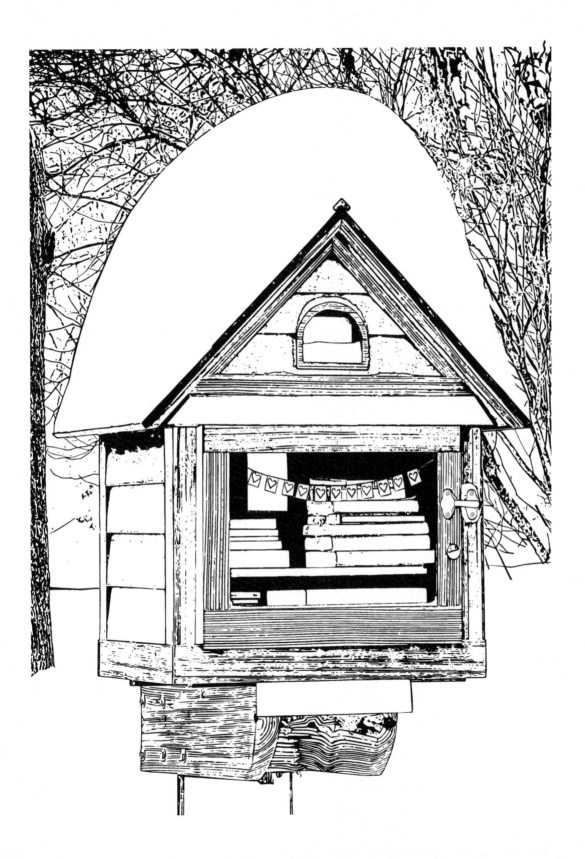

Location: Mumbai, Maharashtra, India

Kiara Bose Roy turned 13 this year, and came across an article about little libraries in the Oprah magazine.

Kiara has always been fond of reading. When she came up to her parents asking "Can we also start one?", they didn't see any reason to say no!

They had a lot of books which they were ready to share with others and when they told their family and friends about it, they were all more than happy to contribute.

Kiara began designing the library. She had a good idea about how it should look. Their carpenter Shiva helped them build it. Anjali, who is a graphic designer and artist, painted it for free since she thought Kiara was doing a good thing by starting a little library.

On the 15th of March 2015 Mumbai got its 1st little library!

The local MLA was invited to inaugurate it, and members of the press were encouraged to cover the grand opening in the form of a celebration with friends and neighbors.

Kiara's initiative has inspired many other people, especially kids, to start their own libraries. One has been started in Indore and there are a couple more coming up soon in Mumbai.

Kiara was invited to be part of a local fair where she put up a prototype of her library and distributed books and pamphlets making people aware of the concept.

Save the Loggerheads Library
Location: North Myrtle Beach, South Carolina, United States

Regena and Harry Heilmann are stewards of the only little library located along the Grand Strand coast of South Carolina. While on vacation Regena read an article about a little library and could not get the idea out of her head. Upon return, she researched the concept and the rest is history.

The theme "Save the Loggerheads" is named for their passion of locating and monitoring the nests of the endangered Loggerhead turtles and accounting for the number of successful hatchlings on Waties Island in North Myrtle Beach.

The grand opening of the library was held in September, 2014. It is adorned with drawings of hatchlings making their way to the ocean as well as a sea turtle reading a book. It also holds a geocache! With the support of their Homeowner's Association, the library is located in a central location at the mail center and serves area homeowners as well as walkers and bikers from other neighborhoods.

Follow them on Facebook: https://www.facebook.com/LFL12319

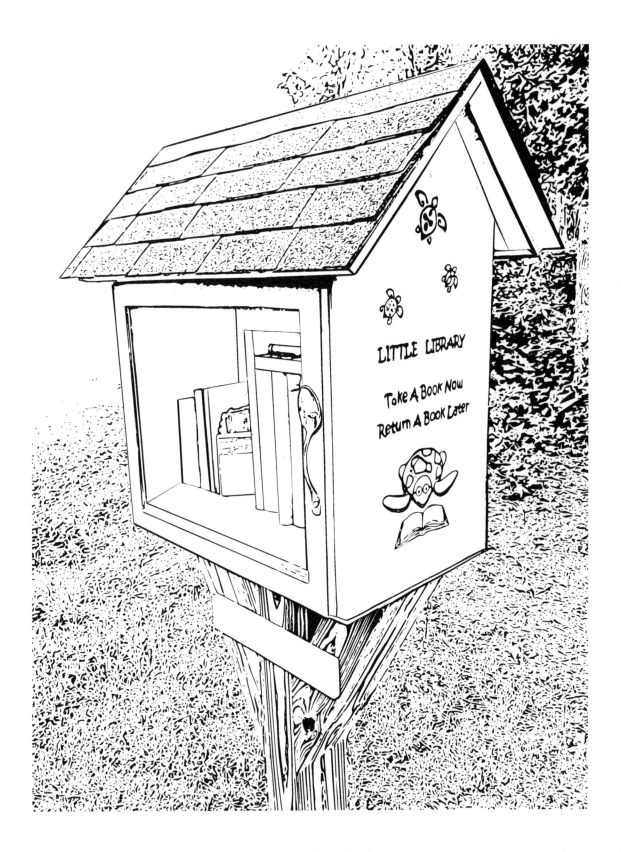

Location: Napa Valley, California, United States

Leisa Jones' library went missing this summer. In her never-ending effort to donate items that she no longer needs, Leisa posted a "curb alert" ad on a couple online selling sites. The items she was offering for free were set out on the curb in front of her house. She took a photo so people could see what was available to take. After she'd posted the ad, she and her daughter joked that they hoped no one took their little library, as it was visible in the picture, but clearly in her yard and not sitting with the other items.

A couple of hours later, as she was leaving to run some errands, she looked over to see which free items were left and noticed that her library was gone! She couldn't believe her eyes! She ran back inside and posted on every local online selling site she could about the disappearance of her library.

Leisa knew it hadn't been stolen, but taken in error since it was in the picture with the free items on the curb. The response she got to her second posting was amazing! People shared her plea for the library's return and asked whoever had mistakenly taken it to please bring it back. She knew that by posting about its disappearance so widely, whoever had taken it would eventually see the posts and know that it wasn't meant to be taken. All Leisa could do next was wait, and pray.

After a couple hours passed a man posted, "Ok. Calm down, everyone. It will be returned later today." Leisa was shocked and thrilled! She went out front to personally thank him for bringing it back when he arrived. It turned out he had a little story for her. His pregnant wife had seen Leisa's unique library in the picture and thought it would be perfect in their baby's nursery. So, his wife asked him to go get it. Like any good husband would do for his pregnant wife, he did as he was told. No questions asked! They both had a good laugh about it. As for Leisa, she's happy to have her not-so-little library back where it belongs!

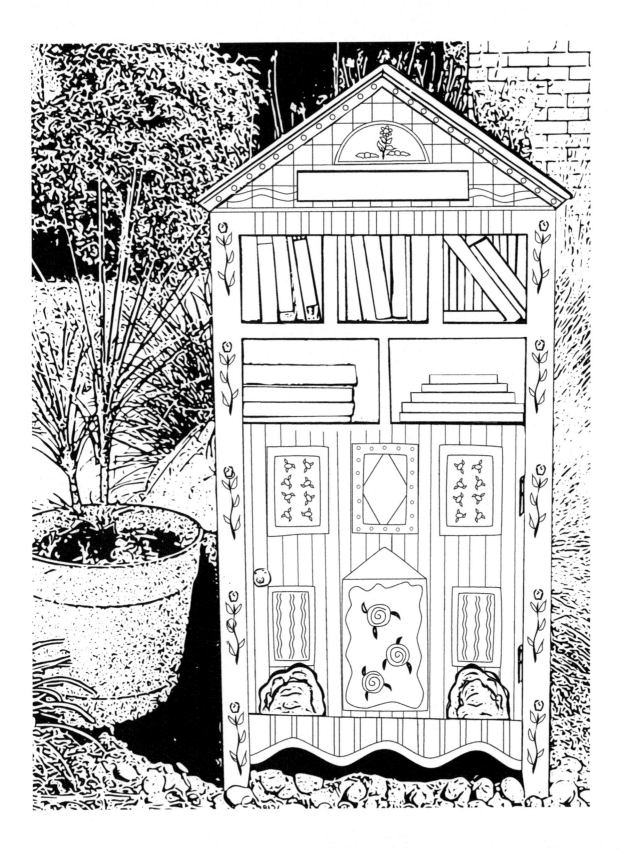

Jet's Minibieb
Location: Zuiddorpe, the Netherlands

Jet's Minibieb (little library) is located at Boekweitstraat 14a 4574 rj, Zuiddorpe, the Netherlands.

It's a library with books for children as well as adults, and it has a very active Facebook page: https://www.facebook.com/Jets-Minibieb-1523366784568956

Mariëtte Koen en Jet started this little library because she lives in the small village of Zuiddorpe, which continues to lose facilities. With Jet's Minibieb, she hopes to keep the contact between the villagers and the visiting readers strong.

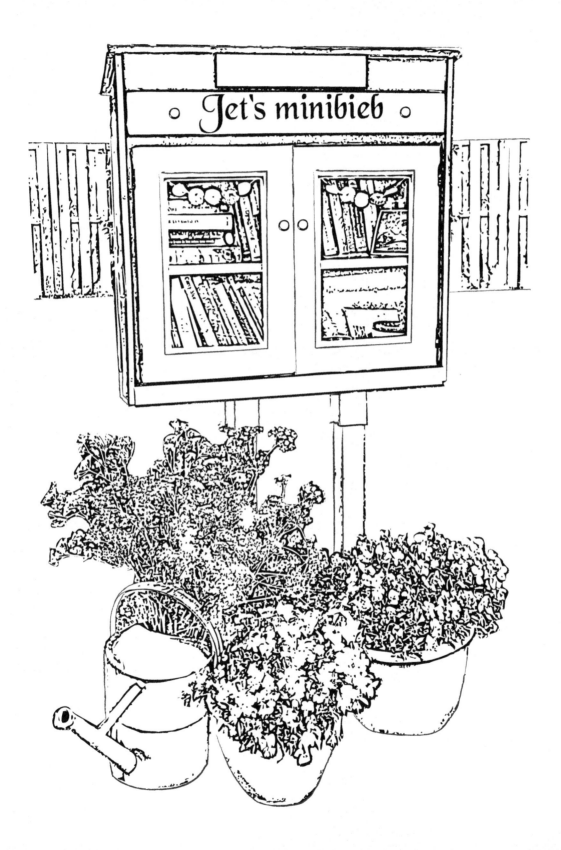

Location: **Central City, New Orleans, Louisiana, United States**

Central City is celebrating the rebirth of one of the greatest cities in the world with a goal of seeing more than 24 little libraries installed locally.

Central City is home to thousands of friends and neighbors, and is both a historically important and culturally vibrant part of New Orleans.

Currently, there are three little libraries in Central City, but there's lots of room and interest for dozens more. It doesn't take a lot of money to install a library, especially if you're using recycled or reclaimed materials to built it. Members of this community have seen first hand how a library can bring an entire block together, forge relationships over books, and serve as important visual markers for neighborhood pride.

Daybreak Little Library
Location: South Jordan, Utah, United States

Daybreak Little Library is still in its infancy, at only a few months old.

Lindsey Lyman wanted to be a part of this incredible movement for quite some time, and during a hard time in her life, she made the decision to become a steward, mostly for selfish reasons. She needed something in her life that was positive that she could focus her energy toward.

There isn't a day that goes by that she doesn't feel overwhelmed with gratitude for this bright little library, sitting out front in her yard. Its brought the very best out of her community and has brought her and others so much joy. Reading has always been a huge part of Lindsey's life and it has been incredible to share her passion of books and reading with her neighbors and their darling families.

A month into this adventure she was blessed by a secret donation of 27 brand new books and a gift card to use towards purchasing additional books. She'll never forget this amazing gesture. The spirit of this library is real and it continues to remind her how genuinely kind people are. She looks forward to the many days ahead, filled with lots of book swapping, story telling and memory making.

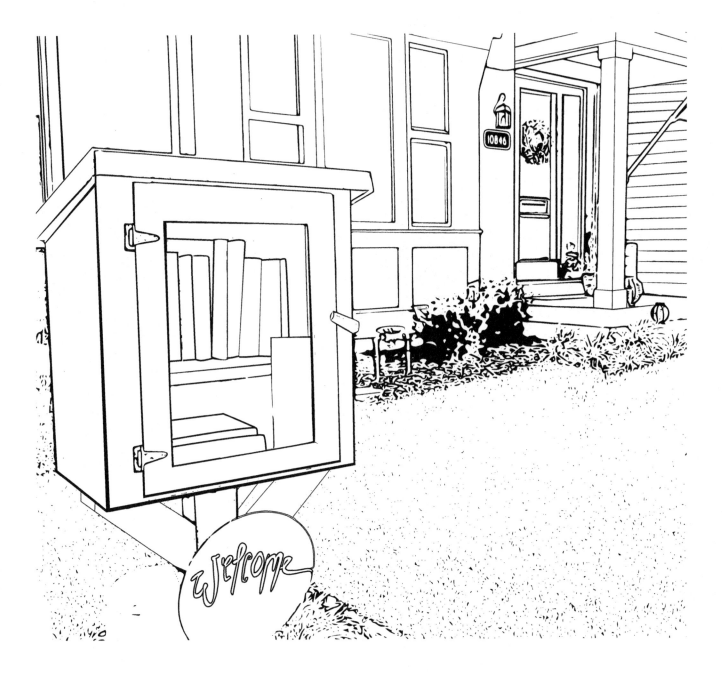

Little Library of Porticello
Location: Porticello, Sicily, Italy

The Little Library of Porticello is the first one in Sicily (South Italy). It was made by a group of young boys with a passion for literature. The library is located in a court of a fishermen's small hamlet in front of the sea. You can find all sorts of books in the library for kids and adults and also in foreign languages.

Since installing the library on May, 6, 2015 Antonio Carini's library has been granted about 250 books. He is proud because, thanks to this small library, many children who did not read before have now discovered the pleasure of reading and the magic of books.

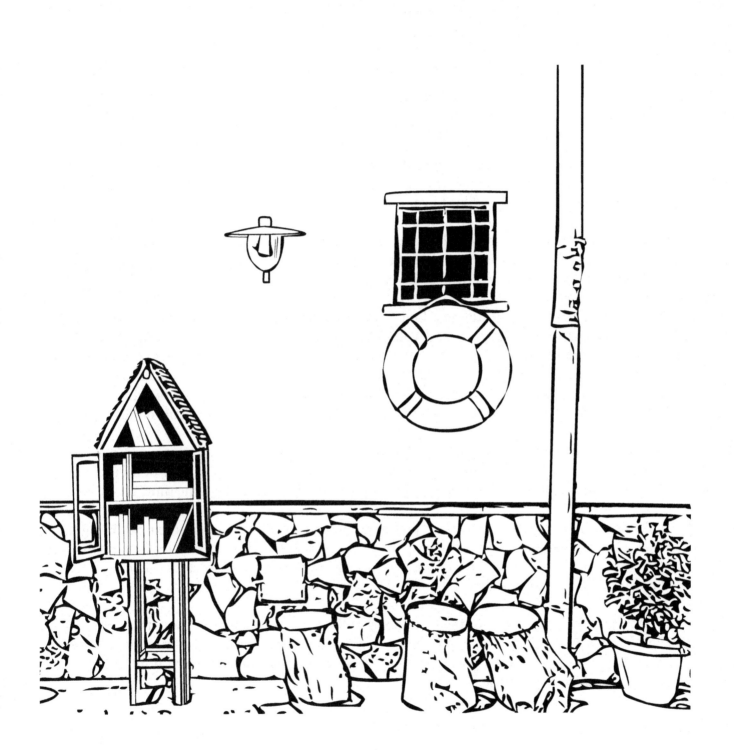

The Pink Palace Library
Location: Memphis, Tennessee, United States

The Memphis Pink Palace Museum's Library started over a lunch table discussion. The staff eating lunch that day slipped into talking about books, one of their favorite topics. They often discuss what they've been reading for work and for fun and make recommendations. That afternoon their bookish conversation changed course toward little libraries because of a recent visit to The Dixon Gallery and Gardens, another local museum which has a little library available for its visitors and staff. As they talked, George Henderson, their preparator who designs, fabricates and fixes exhibits, said he wanted to build one and make it look exactly like The Pink Palace mansion.

The Pink Palace has a very distinctive look. The mansion was built in the 1920s and is clad in pink Georgia marble. It has a green tile roof, elaborate curves, and has been described as having a "Romanesque, rambling design." George Mahan, one of their building's architects, said that the stone had a "rustic or natural finish of variegated gray and pink colors of a million shades or variations." George Henderson developed a painting technique that took four coats of paint to achieve the same look. He also added Plexiglas windows to the top and used stir sticks for the details on the doors.

The inside of this two story library is collaged with photographs of the mansion's interior. Corie Walker, the assistant preparator who is finishing her BFA in Studio Arts at the University of Memphis, used overlaying pictures that make the inside appear "logical and illogical at the same time."

Several staff members helped with taking photographs, and Cynthia Williams, their exhibits graphic designer, printed the images. The first attempt at decoupage failed because the photographs were printed on paper that was too thin so Cynthia reprinted everything on cardstock. George and Corie used polyurethane to coat the library to make it waterproof.

They hope that hosting a place for their neighborhood to exchange books is a way that the museum can be an active part of their community - both to the people who visit and the ones who live nearby. If you find yourself in Memphis, please borrow a book from their unique library. While you're there, be sure to visit them at the museum!

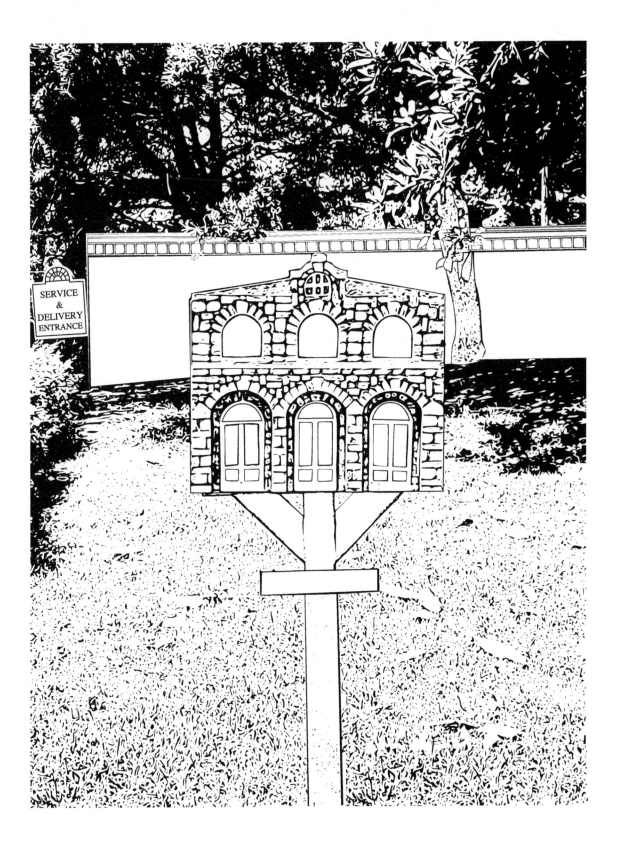

Location: **Taylor, Texas, United States**

Cindy Kelly has always been an enthusiastic reader, and she works in a library. Since she's become a little library steward, she's surrounded by books at work and at home!

Books have taken Cindy many places and she loves to share her love of reading with everyone. Now she can share books from her own front yard with the people that live nearby.

Cindy lives in a small town on a street that gets a lot of foot and bike traffic. Her library is quickly becoming a popular stopping place for her neighbors.

Location: **Philadelphia, Pennsylvania, United States**

Sue Heckrotte's library was her 2014 birthday gift, designed and made by her husband to relate to their house. It's a big hit in their urban neighborhood and has inspired another family to put one up a few blocks away.

Sue cherishes the day she heard a 5-year-old approaching the library with his family, skipping along and singing out, "I see the little library, I see it, I see it!"

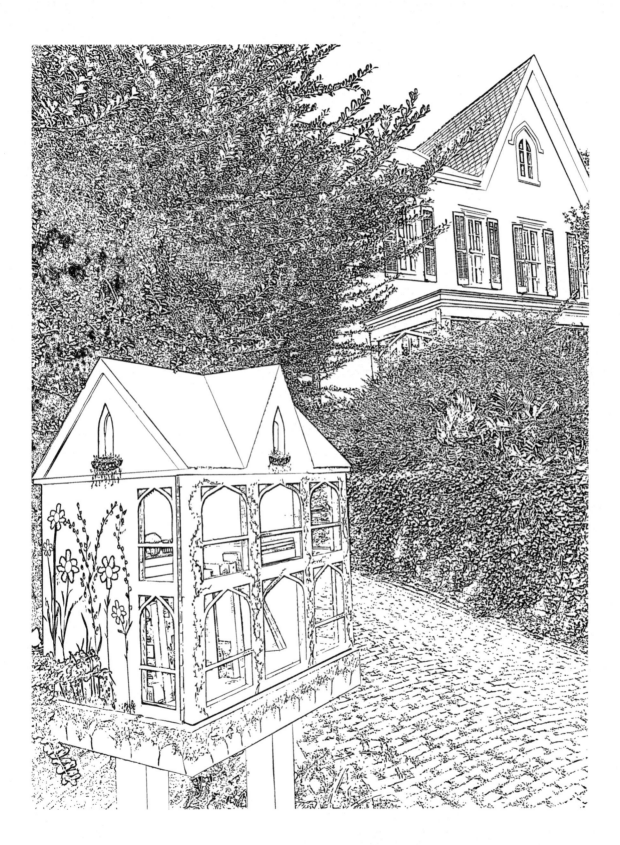

Penny's Little Library
Location: Lincoln, Nebraska, United States

Penny Schmuecker built her little library as a tribute to her mom, Dorothy, who loved books and cats. As a child, there was no shortage of either in their home. Some of Penny's earliest memories are of Dorothy reading to her, changing up the characters' voices and often reading the book in a Southern drawl. The books came to life and Penny was hooked!

As kids, Penny's sisters spent hours at the library with her, perusing their next reads. They were encouraged to participate in summer reading programs and there were always one or two books for each of them under the Christmas tree every year. Her love for reading continued to grow over the years and as an adult, she stopped in bookstores with her mom in every city they visited. It's these times that Penny cherishes most of all, now that her mother is gone. Dorothy's passion for reading lives on in Penny and she loves the idea of being able to share that with her neighbors through her little library.

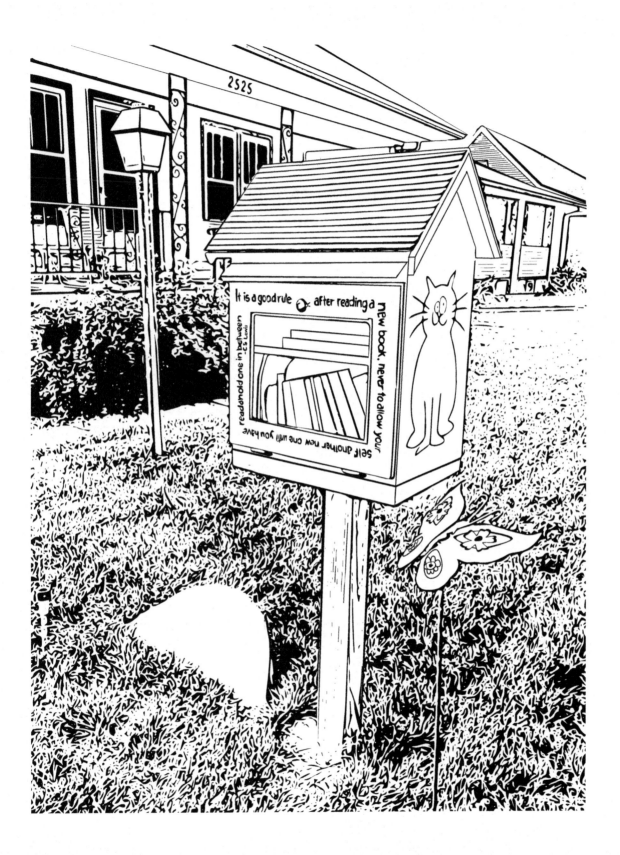

The Rocket Ship Library
Location: Rochester, Minnesota, United States

Ariel Borisch knew she would have a little library of her own as soon as she learned about them. However, the idea of what it would look like evolved over a few years. Her children helped her realize she needed a kid-dedicated box that they could reach, yet she still wanted a place for adults to make use of the selection. So, a double-level box was a must.

When Ariel asked her father-in-law if he could build a little library, he was game even after she told him what she really wanted was for it to look like a rocket ship. He says he really enjoyed the challenge and truly, what he created exceeded even Ariel's imagination. It took a little less than a year from the time she approached him with the idea to the time he had designed and created it. Then, Ariel painted it and they put it up. While Ariel already had a great relationship with her father-in-law, this project was a fun bonding experience for them to collaborate on.

The rocket ship design was a daydream that she fell in love with. Ariel is a self-designated closet-geek and she loves sci-fi and fantasy. It made sense for her and her two boys to embrace the rocket ship theme. It turned out to be a fun way to engage her children with the library as well as the other neighborhood kids. Being one block away from the neighborhood elementary school, this library gets a lot of kid-traffic.

Since opening, Ariel has loved seeing people at the library daily and seeing what goes, what gets brought in and what comes back. The kids' box definitely gets more rotation than the grown-up box, but she's enjoyed some wonderful books that her neighbors have contributed. She's even had the opportunity to correspond with a self-published author right in her own neighborhood.

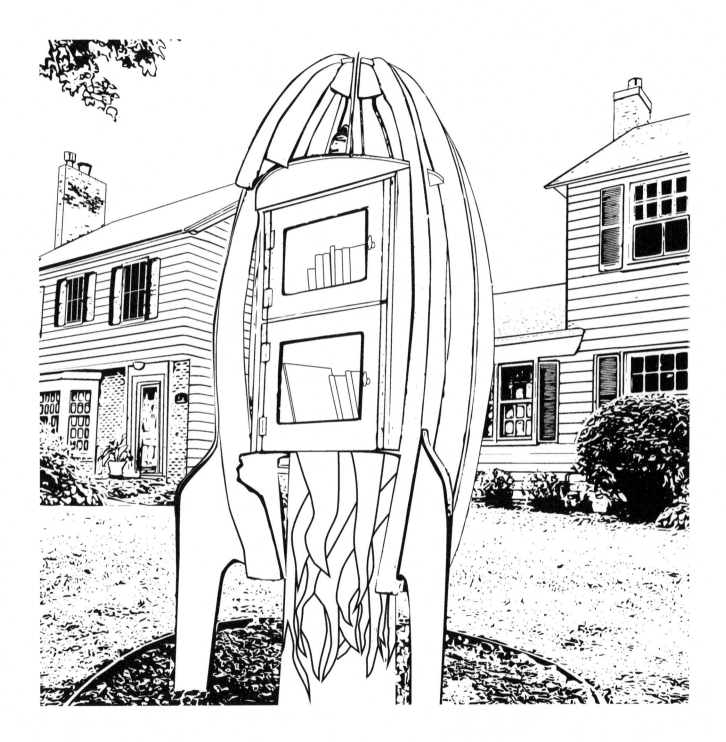

Location: Santiago de Puriscal, Costa Rica

The idea for Jessica Peck's library came from her father, who had built a small structure and filled it with books. Peck and her husband moved to Costa Rica a few years ago. They wanted to help their local community, and installing a little library seemed like a fun and easy way to do so.

The rainy season in Puriscal threatened to damage their library, so the Pecks consulted a local carpenter and friend to waterproof the surfaces and build the structure.

The Pecks have made several community-building project proposals for Puriscal – including improved trash pickup, a public yoga class in the central park, and this library project – all of which were approved by their local government.

The library has been so popular that all the books were cleared out by local readers within 24 hours of it's opening. Visitors often take pictures with the library when they stop by.

Location: Oxford, Michigan, United States

Jane Saxon and her husband built and installed this little library in their rural community in May of 2015. It is a replica of the one room schoolhouse (C1886) that shares the property. It's used by so many people and has served as a great community builder as well. They are proud to have inspired six of their friends to install little libraries in their own communities from Michigan, to Maine to Florida and even to Nova Scotia!

To occasionally pique the interest of folks in their community, Jane and her husband often host neighborhood celebrations such as a 4th of July theme where they stocked the library with patriotic books and book marks. They also placed a brief and fun questionnaire in the library to help keep it well stocked with their neighbor's favorite authors or genres. This was an idea they received from another steward online that's worked well in their community.

Another celebration at their library included a back to school theme with books and ice cream. This gathering included an ice cream social along with surprise grab bags and an offering of new back to school books.

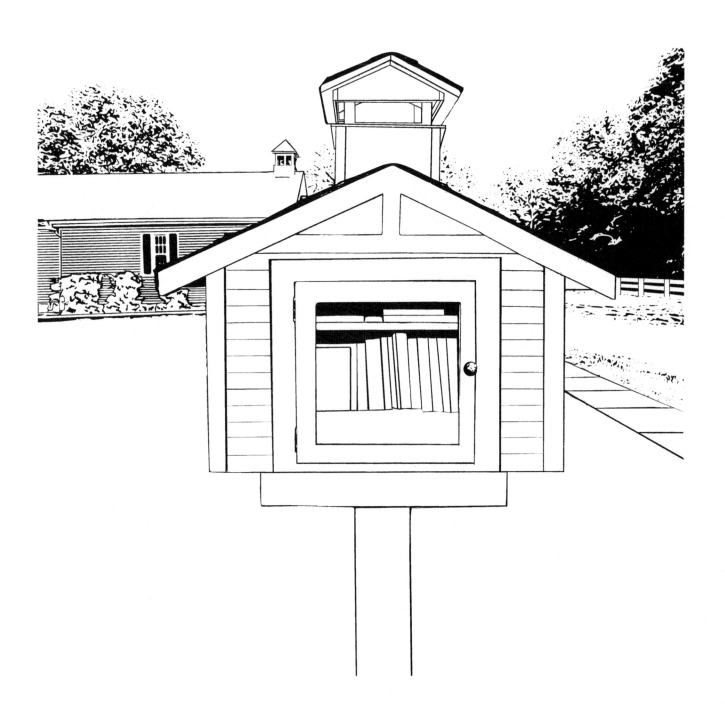

Saltfjellet (The Black Mountain) Library
Location: Saltfjellet, Norway

This library is quite a popular one located on Saltfjellet (The Black Mountain). It is visited often by numerous locals that enjoy the exercise, as well as folks riding fat-wheeled bicycles down the beaten path. There is mostly crime literature featured inside the library.

It was built by Thor Elvin to promote reading in his local community, and to get people out there and reading books, as well as giving them a good workout. It's fun to make the journey with children, who especially enjoy this unique discovery.

A friend of Thor's once told him of a young girl who visits this library twice a week to get a new book for her dad.

The Sinto Avenue Library
Location: Spokane Valley, Washington, United States

Stewards of this library include Ryan & Blair Lingbloom along with their children. The Sinto Avenue Library is currently the only little library in the Spokane area that's crafted from an "up-cycled" newspaper vending machine. The machine was donated by The Spokesman Review Newspaper. This library has been open to the community since July of 2015 and attracts readers of all ages!

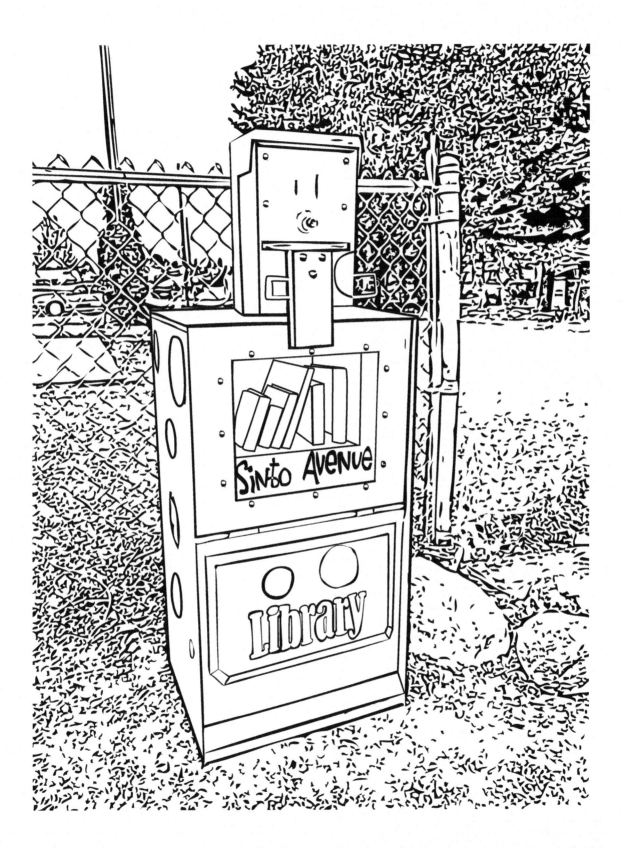

Location: **Khartoum, Sudan**

As a nation, Malaz H. Khojali notes, the Sudanese love to read. She shares the quote "Cairo writes, Beirut prints and Khartoum reads." Sadly, they lack resources such as public libraries and bookstores, so little libraries have become very important in Sudan.

The kids on the block were surprised and thrilled about the library after it became available. Especially considering that the books inside were free! Malaz held a grand opening for the library and invited all her neighbors and friends, along with local reporters from the media to promote the idea.

At first it was successful and people actually borrowed books and brought more to share. Unfortunately, as time passed vandalism and lack of cooperation occurred, including an attempt at burning the library down and entirely emptying it of books. Luckily, the arson was a failed attempt, and friends happily donated more books. They also received a lot of support from other stewards via Facebook.

The little library has received mixed reviews from her community; many embraced the idea, while others resisted it. Through her library's Facebook page, Malaz has been able to spread the idea and inspire other people to build their own libraries. Currently nine have been launched throughout Khartoum and Malaz expects them to increase in the next few months. There is even a mobile library in the works!

Yankee Hill TARDIS Library

Location: Denton, Nebraska, United States

www.facebook.com/tardisfreelibrary/

Rob Smith and his family live on an acreage at the edge of town, near the capitol city of Lincoln, NE. There are no libraries close to their home, and his family watched with interest as little libraries started to appear in Lincoln. They recognized the need for a little library in their own neighborhood and decided to build one.

This was a family project based on the TARDIS from the Dr. Who television show. Rob worked on building, painting and installing the library with his daughter & son. Their TARDIS shaped library is one of the first in the eastern half of Nebraska and has attracted a steady stream of science fiction lovers as well as readers of all ages.

In case this is your first encounter with a TARDIS (Time and Relative Dimension in Space), it is a time machine that is piloted by a time lord known as "The Doctor." The shape of the TARDIS is based on a British police box. The TARDIS can transport its occupants to any point in time and any place in the universe. The television show is based on the adventures the Doctor and his companions have all throughout space and time.

Inspired by the iconic TARDIS, this library plays off of Dr. Who's famous vehicle which was always bigger on the inside. Like the TARDIS, little libraries have the magical ability to transport their lucky patrons to worlds unknown.

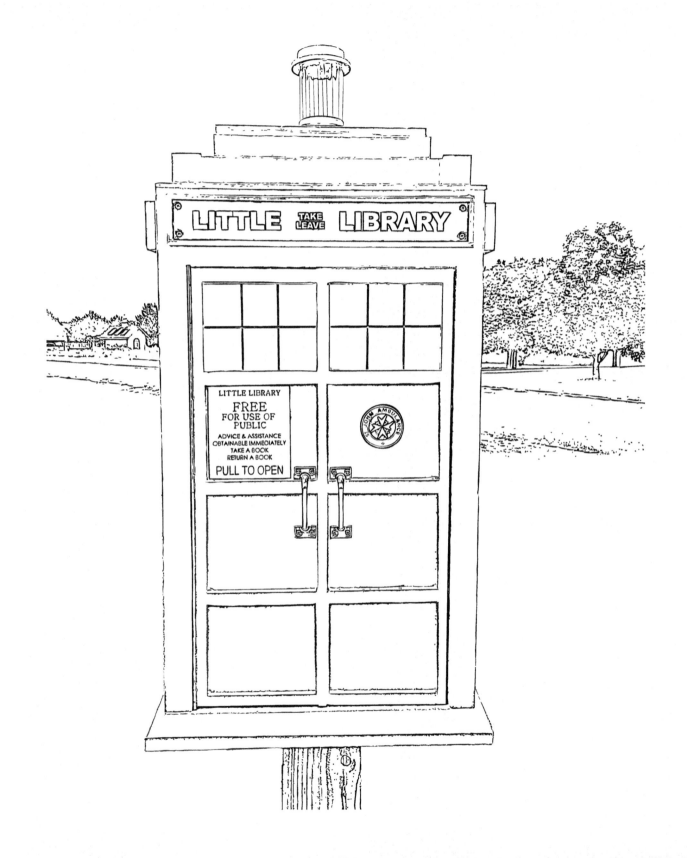

Location: Swansea, Tasmania, Australia

This little library is believed to be the southernmost little library in the world. It's hard to tell for sure, because new libraries are popping up all around the world every day!

This library is located on Nine Mile Beach. Few people actually live in the area, but visitors on holiday drive past and some have holiday houses nearby. Because of this, books don't turn over quickly, but steadily in this library, even in the winter.

Notes of appreciation for this library are often left inside. A sign posted near the library reads "Stop and Look." Some people haven't seen the little library because it's protected within the bushes. Visitors have come down the drive to try and find what they are meant to look at!

Lumos – Fiat lux – Let there be light!
Location: Temecula, California, United States

Erin Brady first learned about little libraries in the summer of 2013 while planning a trip to Minnesota to visit her family and friends. After stopping at several in person, she knew she'd like to build one for her neighborhood. When it came to deciding on her library's theme, she looked to her other interests for inspiration, which included lighthouses and the idea of spreading/shining light to others.

Atop the library sits a lighthouse birdfeeder, which is watched over by Ole the Puffin. The light-themed quotes on the left and right sides of this library read:

"Books – lighthouses erected in the great sea of time."
- E.P. Whipple

"A book, too, can be a star, a living fire to lighten the darkness, leading out into the expanding universe." - Madeleine L'Engle

Lumos – Fiat lux officially opened to the neighborhood on April 2, 2015 and it has been a hit from the start. So much so that when Erin's housing association cited it as being "aesthetically inconsistent" with the neighborhood and it looked like they may need to take it down, neighborhood children put together a petition and took it around to get signatures to save the library.

When the time came to make their appeal to the housing association, more than two dozen neighbors, as well as the mayor, attended the meeting and spoke in favor of keeping it. Erin was granted a 6-month temporary approval in August 2015, which she hopes will convert to a permanent approval in February 2016.

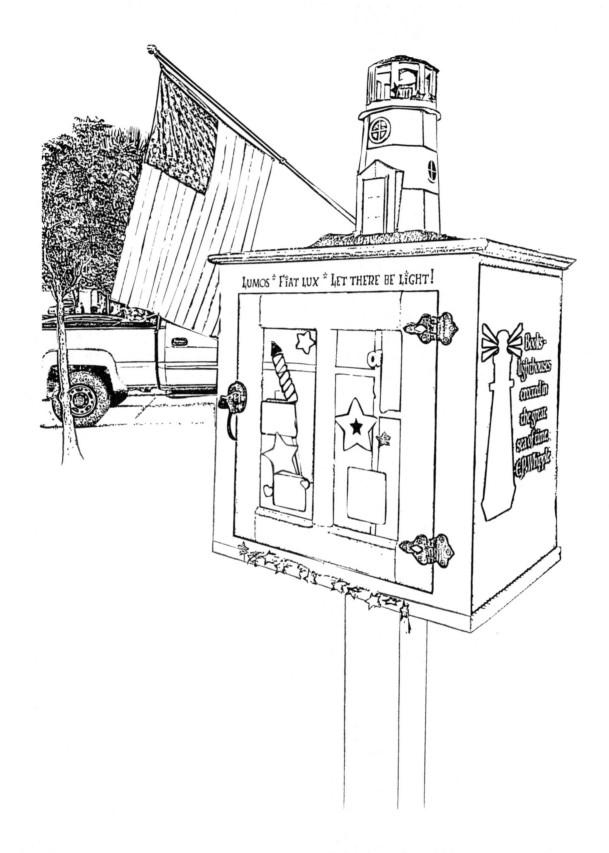

LUMOS * FIAT LUX * LET THERE BE LIGHT!

Books-
lighthouses
erected in
the greate
sea of time.
E.P. Whipple

Garden District Neighborhood Association (GDNA) Library
Location: Tucson, Arizona, United States

"The library is not just encouraging readers, it's giving neighbors opportunities to get to know each other." Rehemma Ellis reported in a March NBC News story. GDNA residents, Meg Johnson and Judy Ostermeyer, built and erected the library. Meg noted that "Judy was the creative genius, architect, general contractor, interior designer, and artist behind the project, while I was the loyal sidekick and deep pockets." (Meg paid for the materials, helped hold things and supplied some cool old doors she had been holding onto for years!) When Meg and Judy were erecting the library, neighbors turned out to see what was happening and ended up chatting and donating books, wood for roof modifications, and book marks.

On November 6, Liz Miller, past Director of Pima County Libraries, and GDNA's very own Kathy Konecny, manager of Martha Cooper Library, cut the red ribbon and gave their blessing to officially open the library which has both children and adult books. Moments later, a kindergartener was enthusiastically looking through the books, joyously announcing her good fortune that she was able to come and trade for a new book any time she wanted!

More information and photos of this library can be found on the website below:
http://gdna.weebly.com (click the drop-down menu labeled "About GDNA")

West Bloomington Book Bike
Location: Bloomington, Illinois, United States

http://www.westbloomington.org/book-bike/

The West Bloomington Revitalization Project (WBRP) welcomes the Book Bike to West Bloomington and the rest of the Bloomington-Normal community. Adapted from an idea developed by Chicagoan Gabe Levinson, the WBRP Book Bike visits the Bloomington farmer's market each week from 9:00 – 11:00 a.m. and travels around the west side and other spots in the community to bring free books to children and adults.

The Book Bike is a 3-wheeled Worksman bike. On its front platform is a book carrier that folds out into book shelving. The WBRP stocks the bike with donations of new and gently used books from residents throughout their community.

The Book Bike represents an integral part of the WBRP initiative to educate local youth and connect their community through reading and literacy efforts. It reflects their commitment to sustainability and to individual connections that strengthen their sense of neighborhood and refresh their ties to one another. The expectation is that the Book Bike will be out in the community every weekend, weather permitting, and that it will continue to bring books and people together in happy and surprising ways.

The Book Bike is made possible by donations from Chris Koos and Vitesse Cycle; Mark Fagerland of Unique Design, who donated the design, material, and labor for the custom-made book carrier; and several community donors, including Mike and Cindy Kerber, George and Myra Gordon, Karen Schmidt, and Earl and Carol Reitan. The Illinois Prairie Community Foundation Donor Advised Fund was instrumental in helping them meet their goal.

With a full load of books, the bike is estimated to weigh around 200 pounds. The WBRP is grateful to strong friends & neighbors, IWU students, McLean County Wheelers, the ISU Bike Club and other strong and hearty bike riders who are willing to help get the Book Bike around.

The WBRP is happy to arrange visits by the Book Bike and looks forward to having celebrity readers throughout their community share the love of reading and the community connections that books bring to us all.

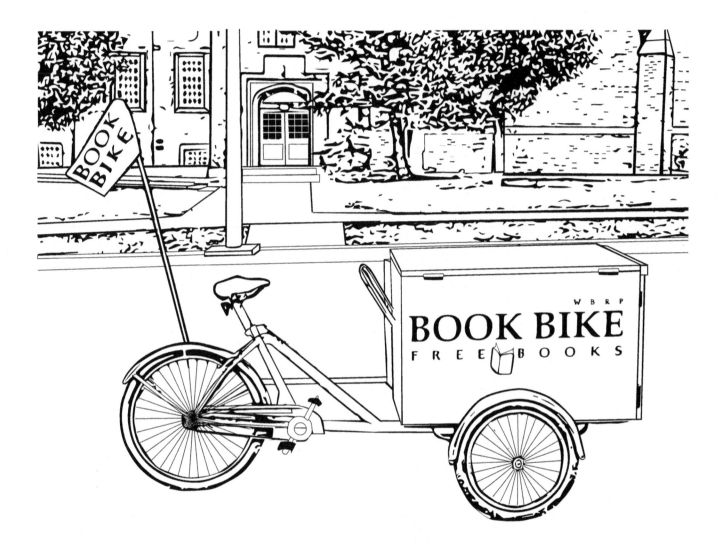

The Sawtooth School for Visual Arts Library
Location: Winston-Salem, North Carolina, United States

The Sawtooth School for Visual Arts (SSVA) recently acquired their little library. SSVA is thrilled to have their own little library, as it is a true asset to their school. SSVA is located in the heart of the Milton Rhodes Center for the Arts; providing a unique place for people to gather and enjoy the arts in a thriving downtown Winston-Salem.

SSVA MISSION

The mission of Sawtooth School for Visual Art is to strengthen their community's creative core by providing high-quality instruction and hands-on visual art experiences for students of all ages, backgrounds and skill levels.

VISION

Sawtooth School for Visual Art will be recognized as the regional leader in community-based visual art education by providing unique and inspiring experiences, sparking creativity and encouraging connectivity throughout the region.

ABOUT

The Sawtooth School is located in the heart of downtown Winston-Salem, NC, the "City of Arts and Innovation." A nonprofit funded partner of the Arts Council of Winston-Salem and Forsyth County, the Sawtooth is housed in the Arts Council's Milton Rhodes Center for the Arts.

As the only community art school in Winston-Salem, the Sawtooth plays an integral role as the "incubator" for visual artists, art lovers and art collectors. SSVA offers a broad range of classes and workshops for all ages and skill levels from beginner to advanced. In addition to their adult classes, they have a strong youth program that provides age-appropriate courses throughout the school year as well as art camps during the summer months.

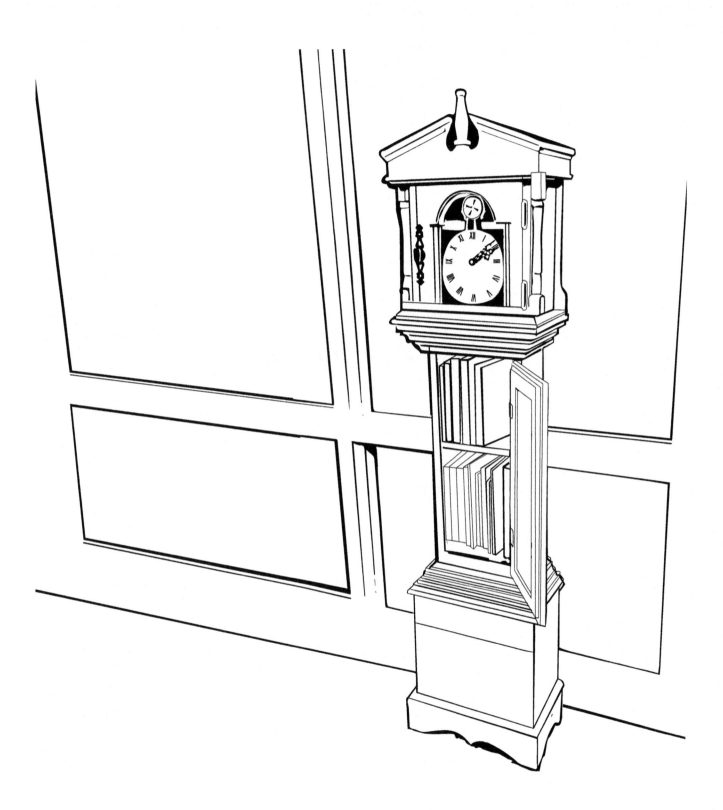

Sir Owen, the Little Library
Location: South Jordan, Utah, United States

I began life in England in the mid-1930s as a K6 telephone box. Many of the specific details of my early life and involvement with Station X remain subject to the Official Secrets Act. Suffice it to say that I survived the dark days of the Second World War by keeping calm, and carrying on. I saw post-war reconstruction, the beginning of the Cold War, and the literary and cinematic rise of a certain secret agent on Her Majesty's Secret Service.

Emigrating to the United States in the early 1970s when the Pound was decimalized, I served as a telephone box for another 30 years on this side of the pond. However, with the rise of new mobile technology I eventually fell into disuse and disrepair, and was decommissioned as a functioning telephone box in early 2006. I endured the antique store circuit for several years, until finally I was rescued and repurposed into my current function as a neighborhood little library, opening on August 3, 2015.

Although this next chapter of my life may not be as exciting as London during the Blitz, I am right enjoying my new accommodations, sharing my love of books and reading with the community. Like a friendly grandparent who's always ready with a storybook, a warm cookie, or perhaps even a poem, I hope to bring a smile, a chance to slow down and connect with friends old and new, and a nostalgic reminder of life as it once was.

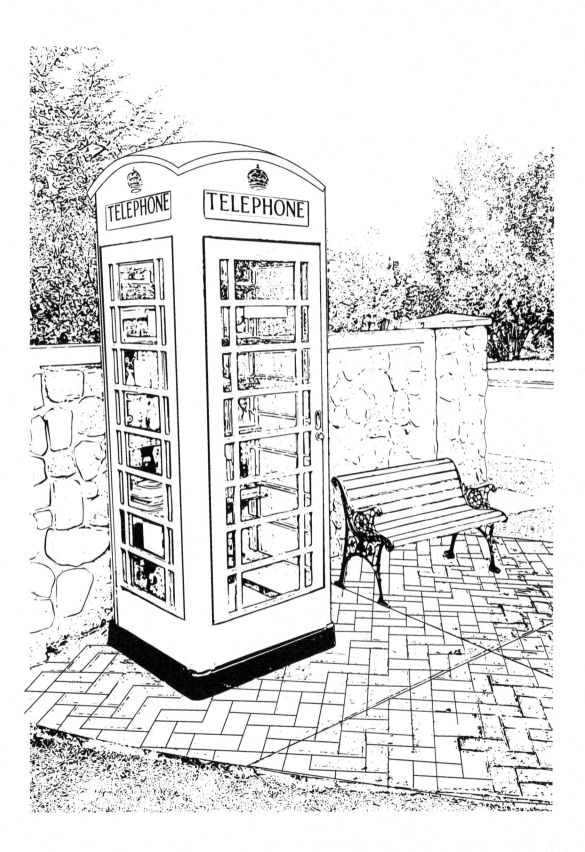

Little Library - Stirchley
Location: Birmingham, West Midlands, United Kingdom

Elenor Carroll is a confirmed bookaholic of which her family is quite tolerant. She also works in a library! Her friend saw an article about little libraries and thought it would be a perfect fit for her, and so it is.

Although there are very few in the United Kingdom, Elenor didn't let that stop her. This is the first library of its kind in Birmingham, though it is a large city. Hopefully the presence of this library will start a trend in the area.

This library was built by Elenor's sister-in-law using bits of left over wood from the Birmingham Repertory Theatre where she works. Elenor's son helped to varnish it and her husband put it up. Her library has been up and running for over a year.

Their neighborhood is quiet so Elenor is happy when she sees somebody use the library and she is getting lots of positive feedback. There is also a geocache connected to her library and a Bookcrossing club recently started using it as a release point for their books.

Wings of the Air
Location: Lincoln, Nebraska, United States

As the parents of Lacey Losh, Bob and Donna DiPaolo are very proud to have their library included in her coloring book, even though Lacey didn't ask them until another library failed to make the publishing deadline. (They're okay with being 'Plan B.' LOL!)

Wings of the Air is a celebration of their wild and domestic feathered friends as well as a favorite book, Black Elk Speaks. May the patrons of this library derive as much pleasure from it as Bob and Donna have from their many feathered friends.

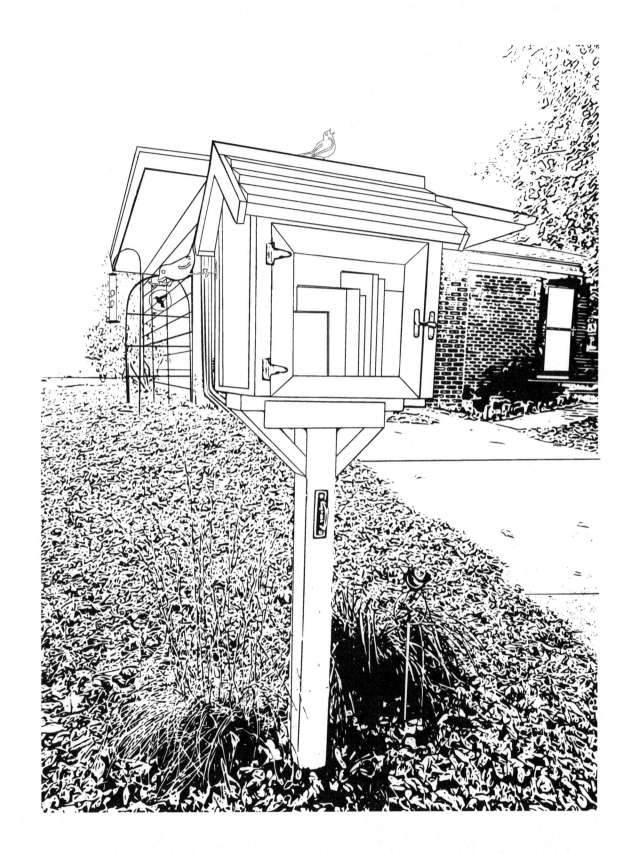